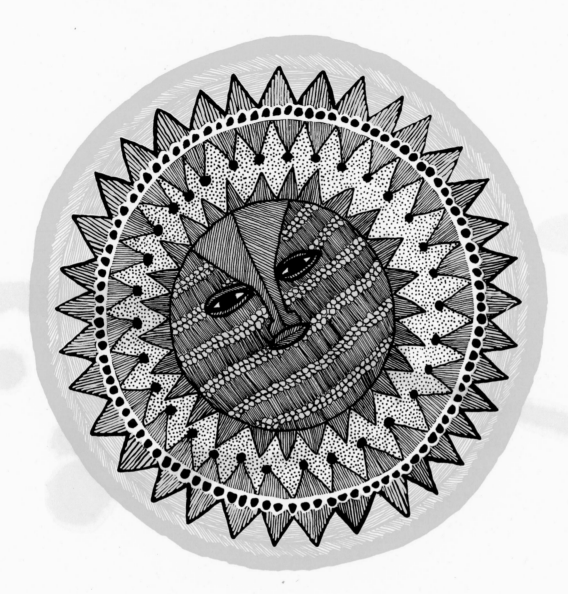

Sun and Moon

Folk Tales by Various Artists

Song of the Sun and Moon

When clouds surround the ringed moon
We know
Rain's not far away

When there's an eclipse of the sun
We mark
Good and bad that day

When fiery lightning strikes the earth
We know
A harvest will come our way!

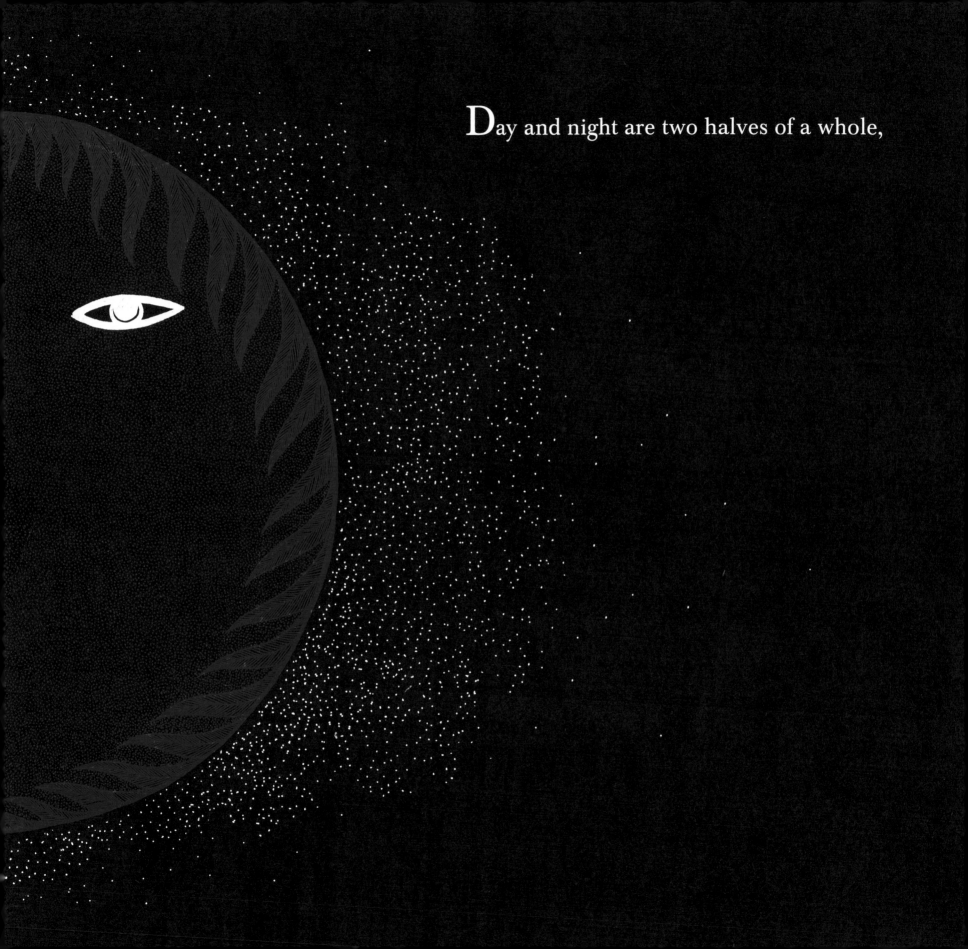

Day and night are two halves of a whole,

and so are the sun and moon.

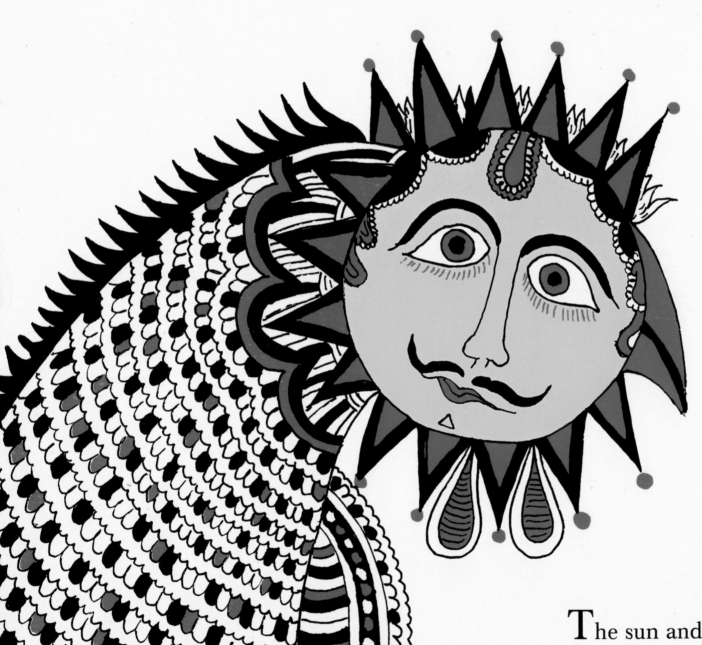

The sun and moon are married...

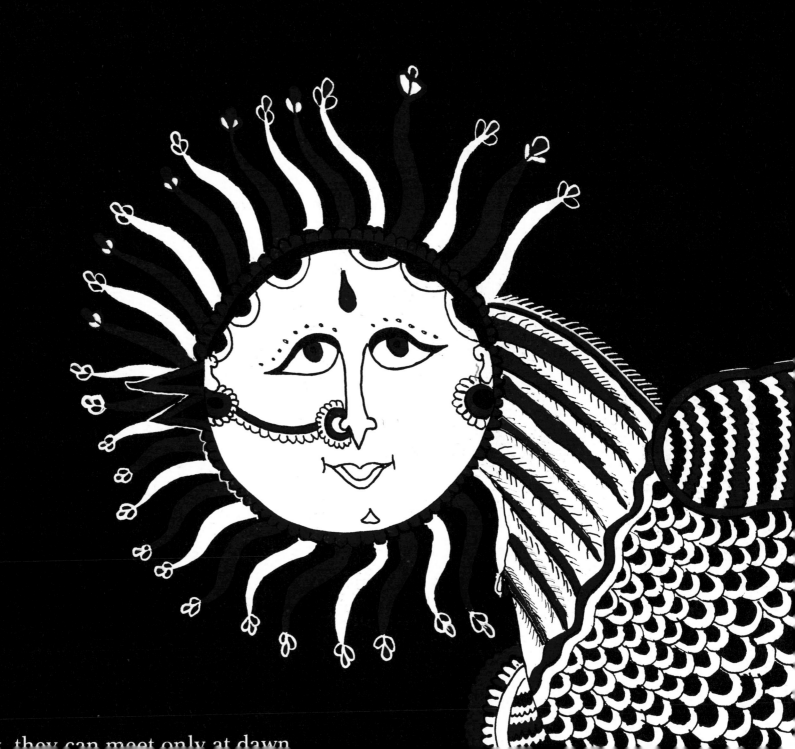

but sadly, they can meet only at dawn,

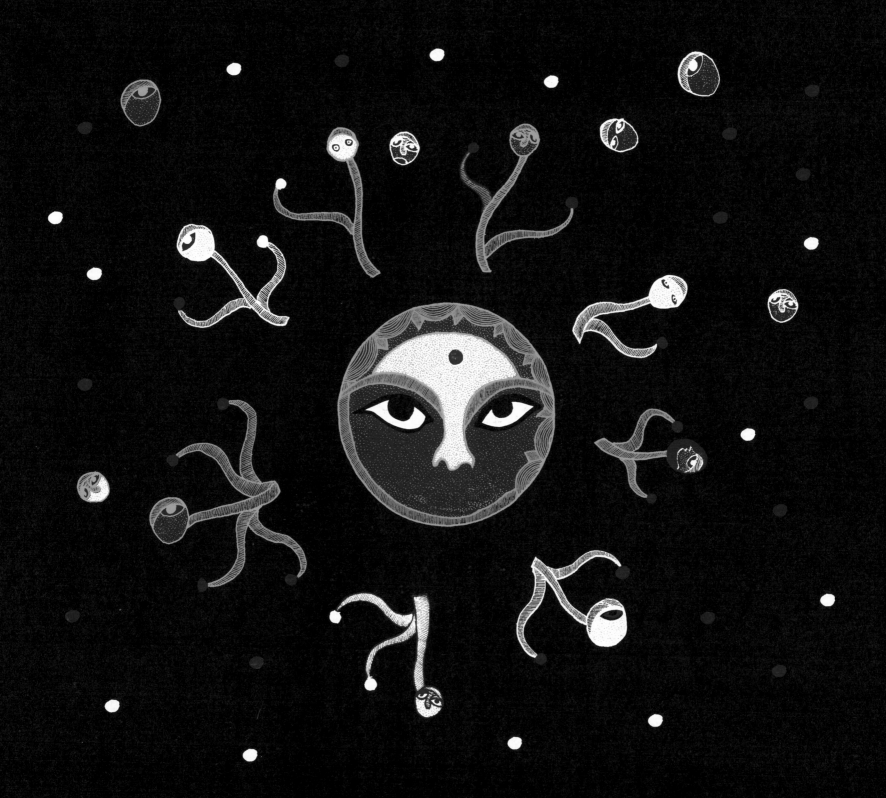

The moon is surrounded by her many children, the stars.

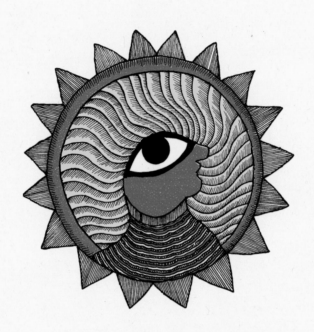

...while the sun is always alone.

The sun gives birth to life...

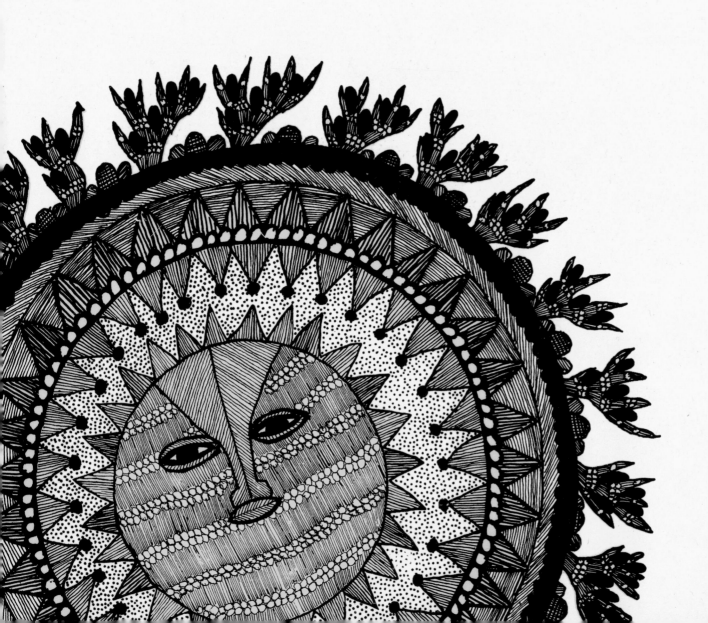

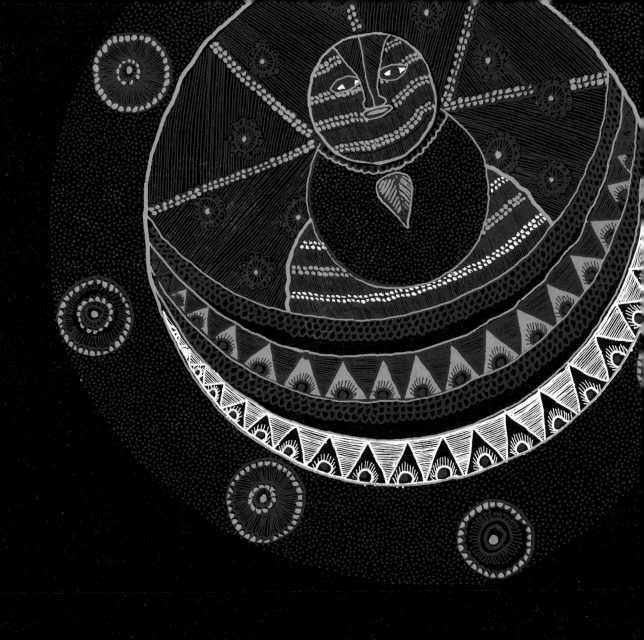

...and the moon gives rise to time.

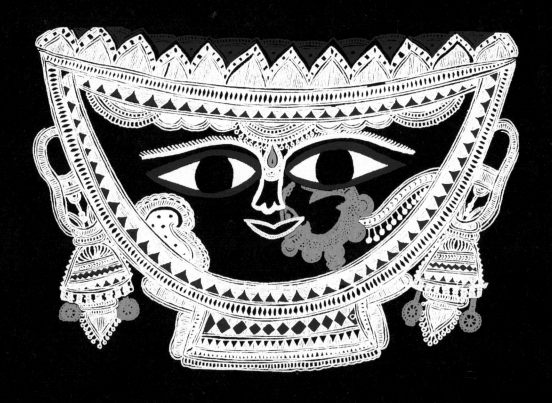

We pray to the Moon Goddess, twice a month...

...and to the Sun God, once a year.

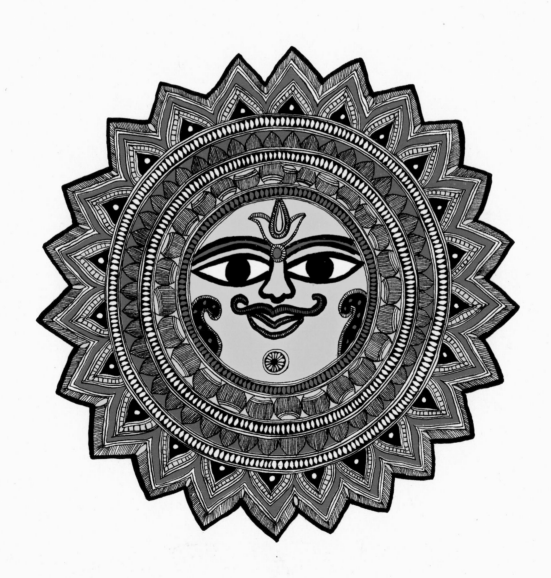

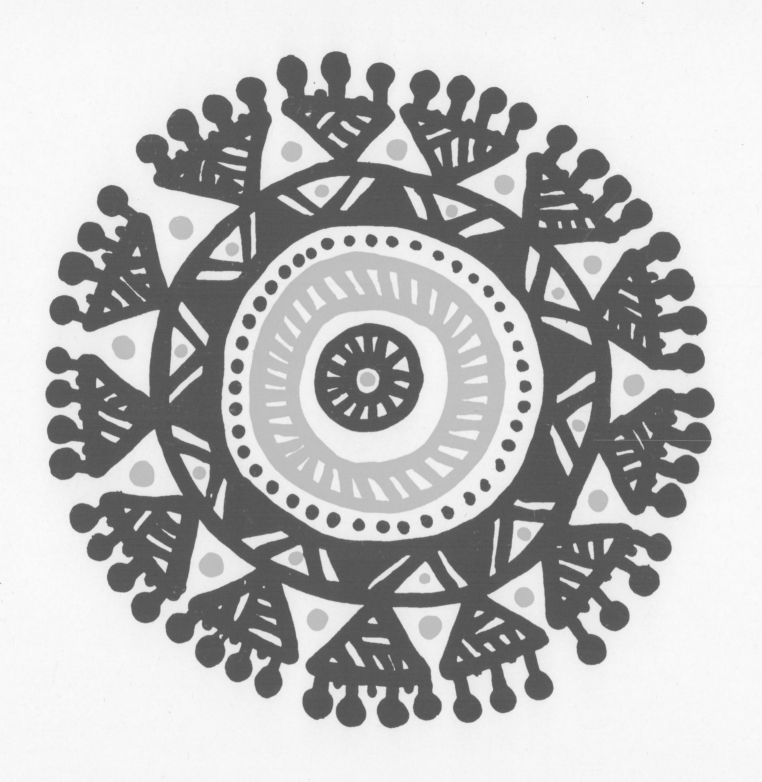

I am great, says the sun, for I make the world shine with light.

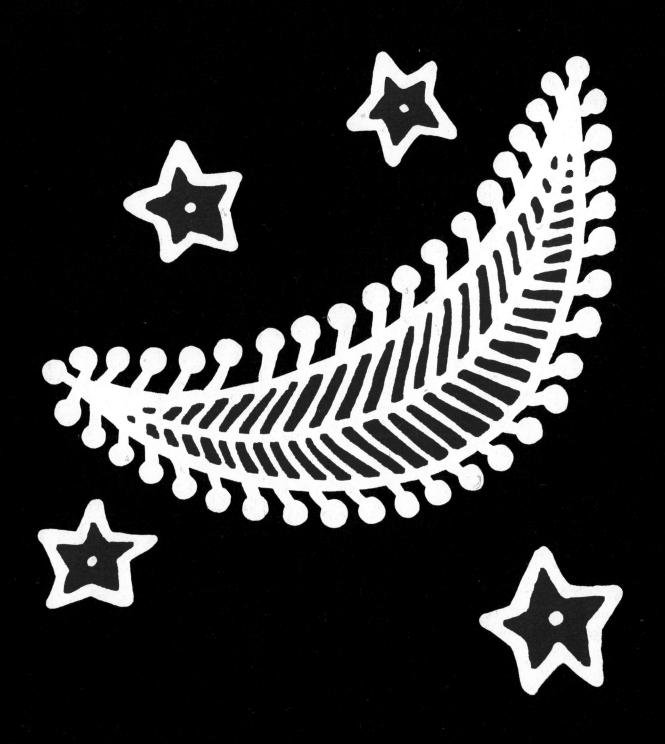

I am greater, says the moon: without me, the world is a sad sight.

Sun and moon are always related to each other.

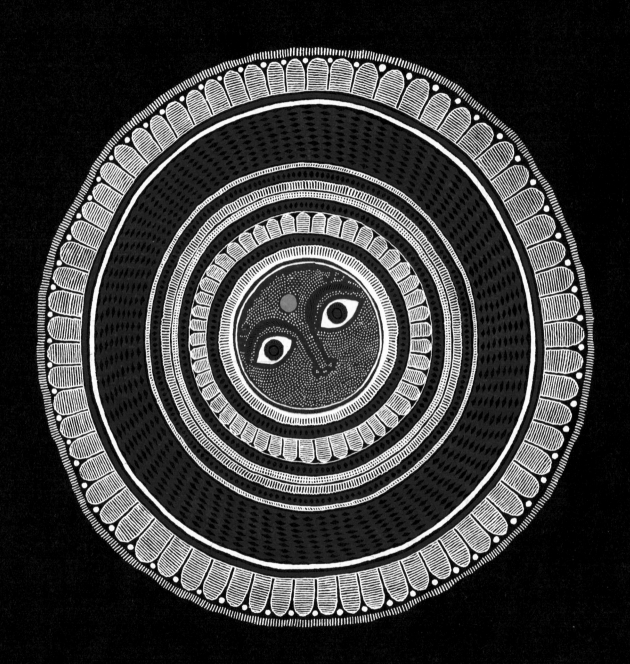

In our tradition they are brother and sister, born from the same mother.

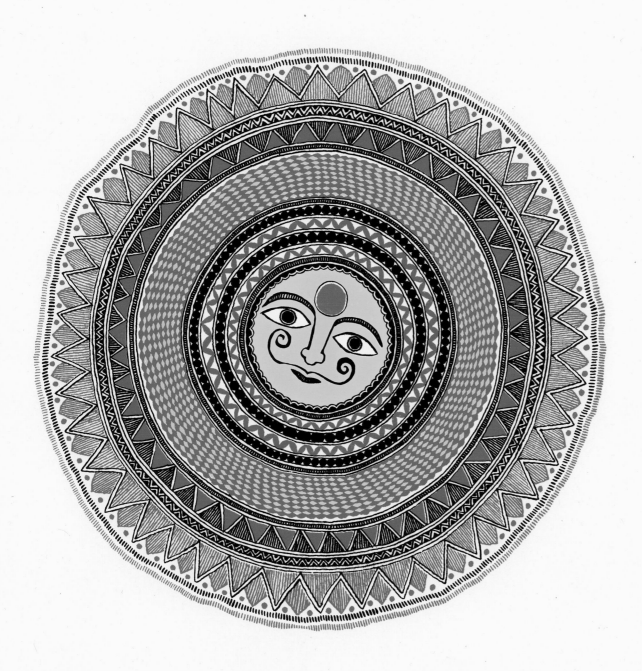

Worshippers at the sun temple greet the rays of the rising sun...

...and wait patiently until night falls to catch sight of the beautiful moon.

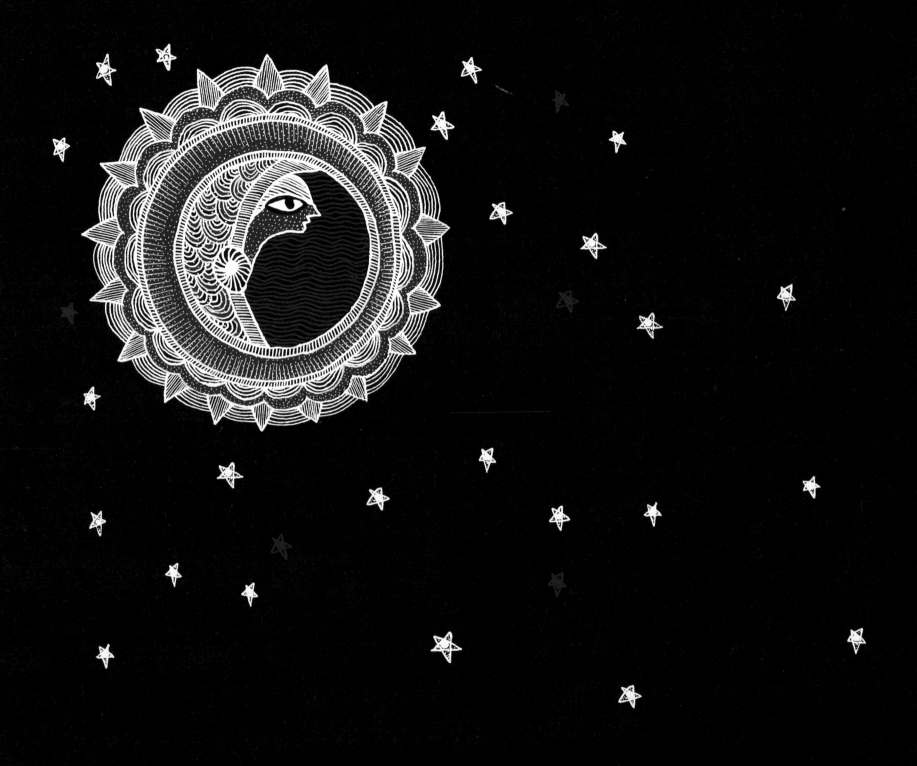

The moon is cool and generous.

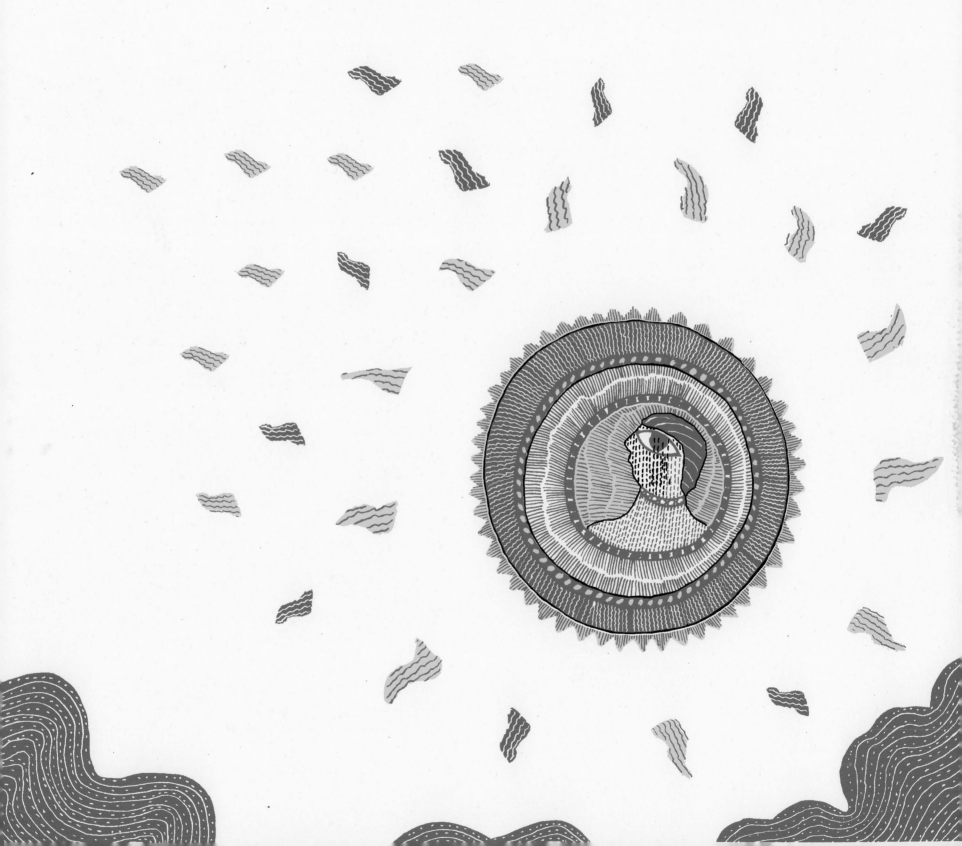

The sun, hot and fierce.

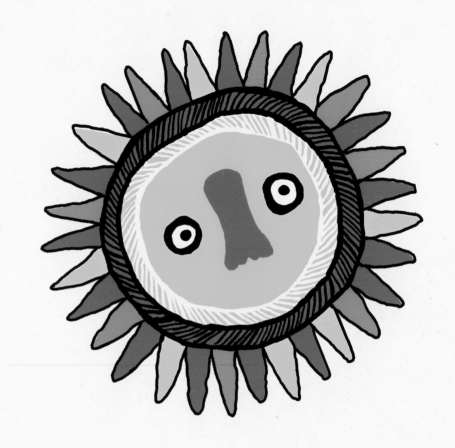

We're happy to greet the sun when the day begins...

...and the moon tells us when it is time to relax.

A Sun and Moon Story

Why is the sun so burningly hot, while the moon stays cool and serene? It is said that there was once an old woman, who had two children, a boy called Sun and a girl called Moon. They were poor, but she made sure the two never went hungry. One day, the children were invited to a neighbour's house for a feast. The old woman asked them to bring back some food for her. The boy ate his fill, but forgot his mother's request. The girl, however, remembered, and brought home some food, which she had hidden under her clothes. The old woman was furious with her son. "I'm burning with hunger!" she said. "From now on, may you forever be hot and flaming!" She turned to her daughter and said: "Bless you for cooling the hunger in my stomach. May you remain cool always!"

Durga Bai

Tribal folk pass through the year – marrying, living and dying – in keeping with the rhythm of the sun and moon. In our belief, the sun and moon are gods. Without the sun, there would be no life – no plants or animals or human beings. The moon waxes and wanes, and all our important dates – rituals, festivals and ceremonies – are marked according to her phases. On a new moon day, we celebrate the Green Festival – this is when the earth weds the god of grain. During the time of the waxing moon, we wake up the sleeping earth with song and drumbeat. The moon calendar must be put together carefully, not everyone can do it. In my community, there is a group of fisherfolk known for their special sightings of the moon: they see her when she is reflected in the water at night.

Ramsingh Urveti

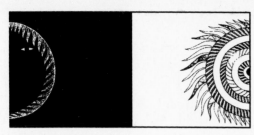

Bhajju Shyam

Art: Gond | Region: Madhya Pradesh
This ritual and functional art from the Gond tribe explores the relationship between humans and the natural world.

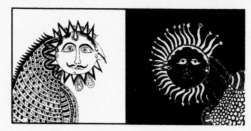

Jagdish Chitara

Art: Mata-Ni-Pachedi | Region: Gujarat
Created by the nomadic Vaghari community, this votive art explores myths and stories around the Mother Goddess and local legends.

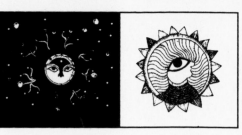

Subash Vyam

Art: Gond | Region: Madhya Pradesh
This ritual and functional art from the Gond tribe explores the relationship between humans and the natural world.

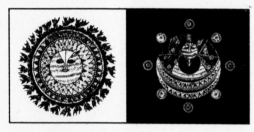

Ramsingh Urveti

Art: Gond | Region: Madhya Pradesh
This ritual and functional art from the Gond tribe explores the relationship between humans and the natural world.

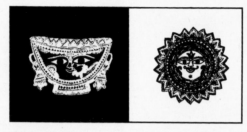

Dulari Devi

Art: Madhubani | Region: Bihar
The themes for this indigenous decorative and festive art include Hindu myth, esoteric spiritual symbols and natural scenes.

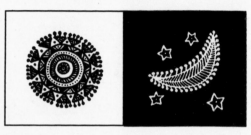

Sunita

Art: Meena | Region: Rajasthan
This indigenous decorative art is painted on walls and floors of houses, and features animals, plants, and mother and child.

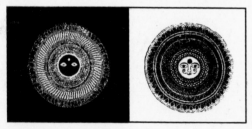

Rambharos Jha

Art: Madhubani | Region: Bihar
The themes for this indigenous decorative and festive art include Hindu myth, esoteric spiritual symbols and natural scenes.

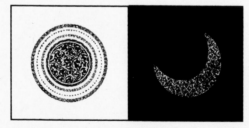

Radhashyam Raut

Art: Patachitra | Region: Orissa
This textile art originated in the ancient temple of Puri, where artists used to paint the walls with stories of the local gods.

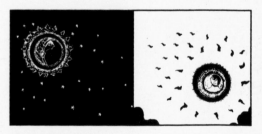

Durga Bai

Art: Gond | Region: Madhya Pradesh
This ritual and functional art from the Gond tribe explores the relationship between humans and the natural world.

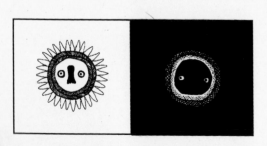

Bhaddu Hamir

Art: Pithora | Region: Gujarat
This ritual and decorative art is painted on the walls of houses, and features animist beliefs, local myths and legends.